Illustrious
By
Artist
Akeem Wayne

Col-or-ist

A colorist is an artist who adds color to black and white line art.

Thank you for purchasing my first ever coloring book! As the person adding color to this series of line art drawings, you as well are an artist. Enjoy making these drawings your own! Relieve stress, reach goals, and decorate your home with the work you've help to create!

-Akeem Wayne

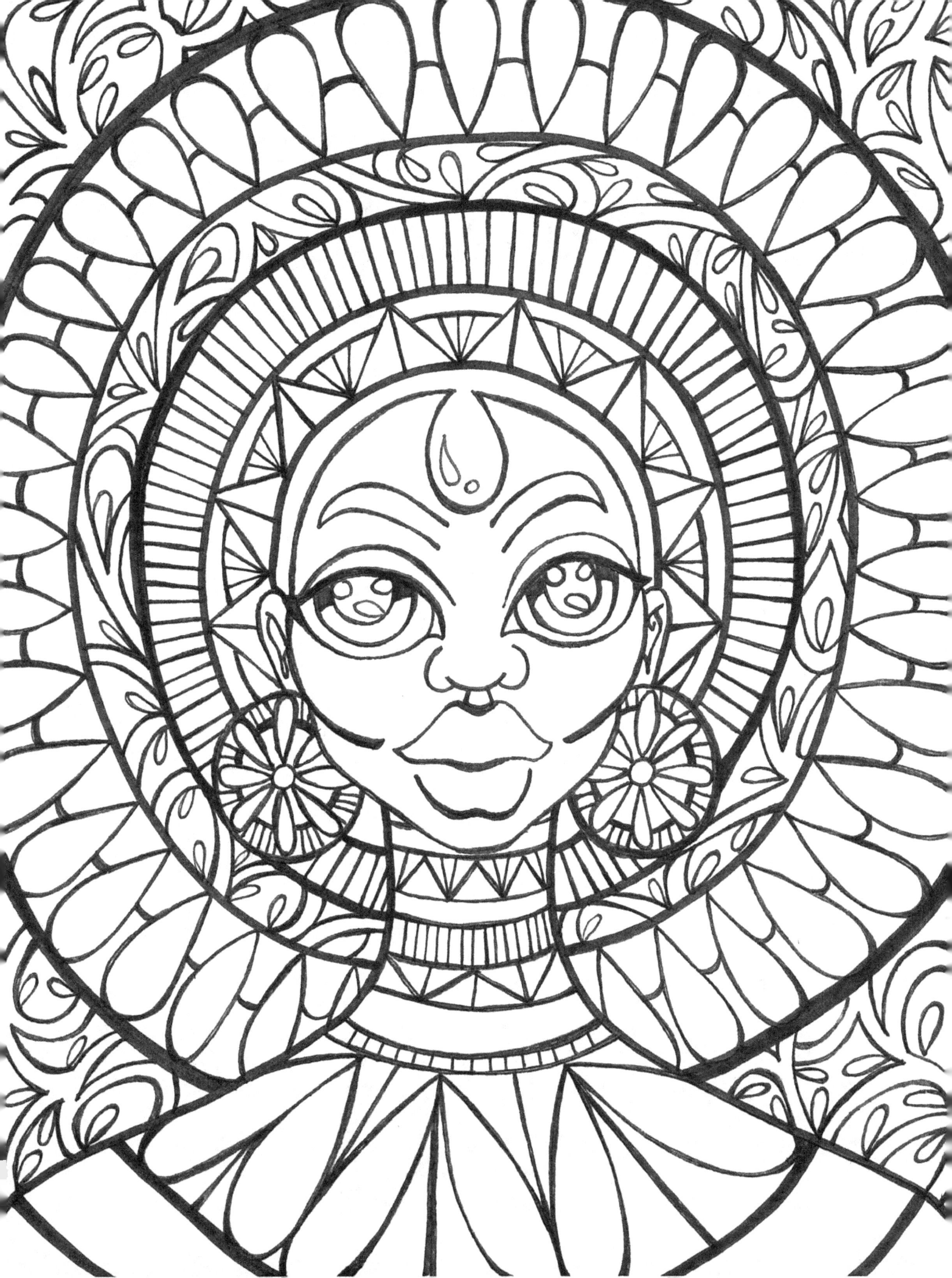

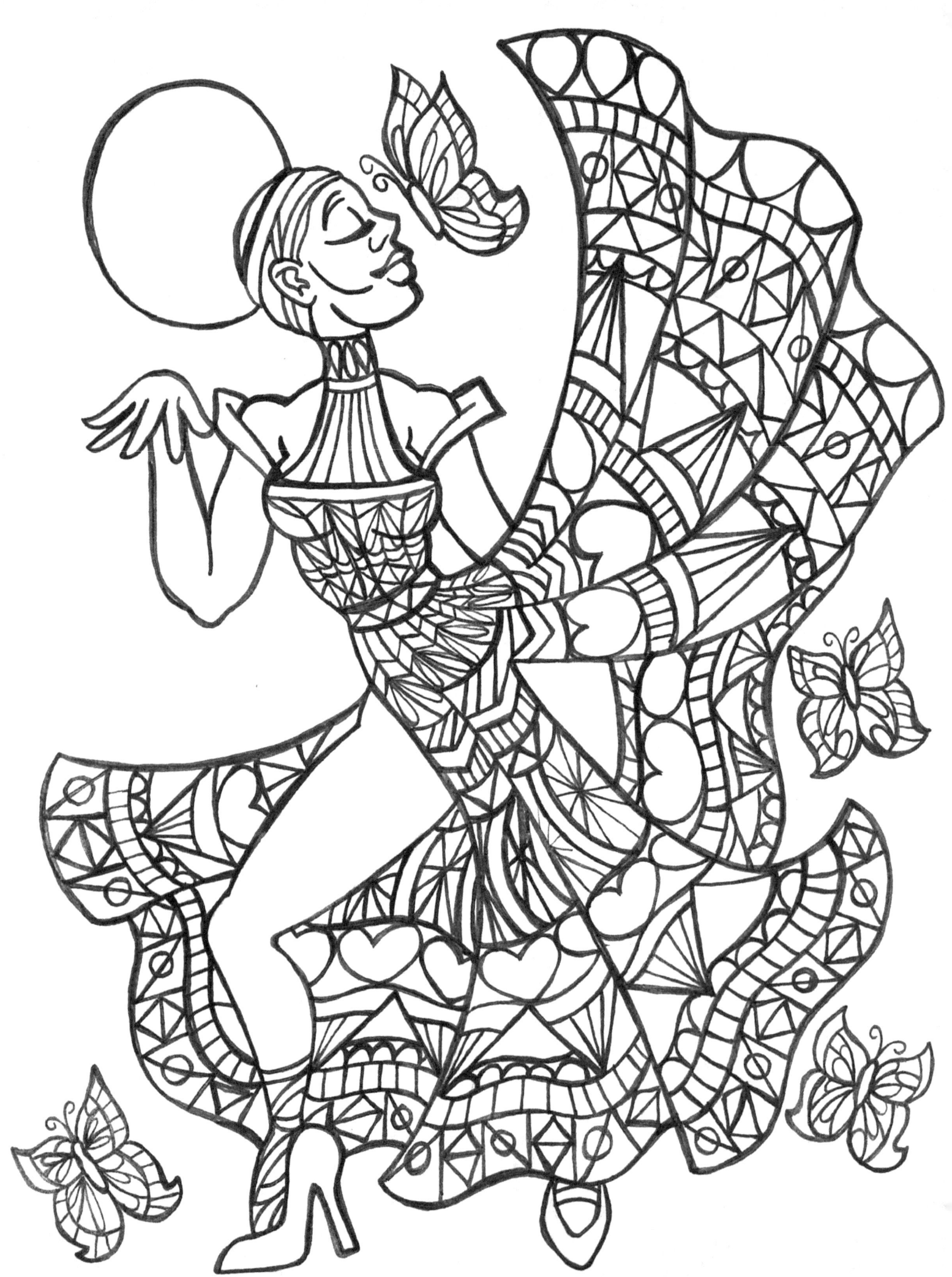

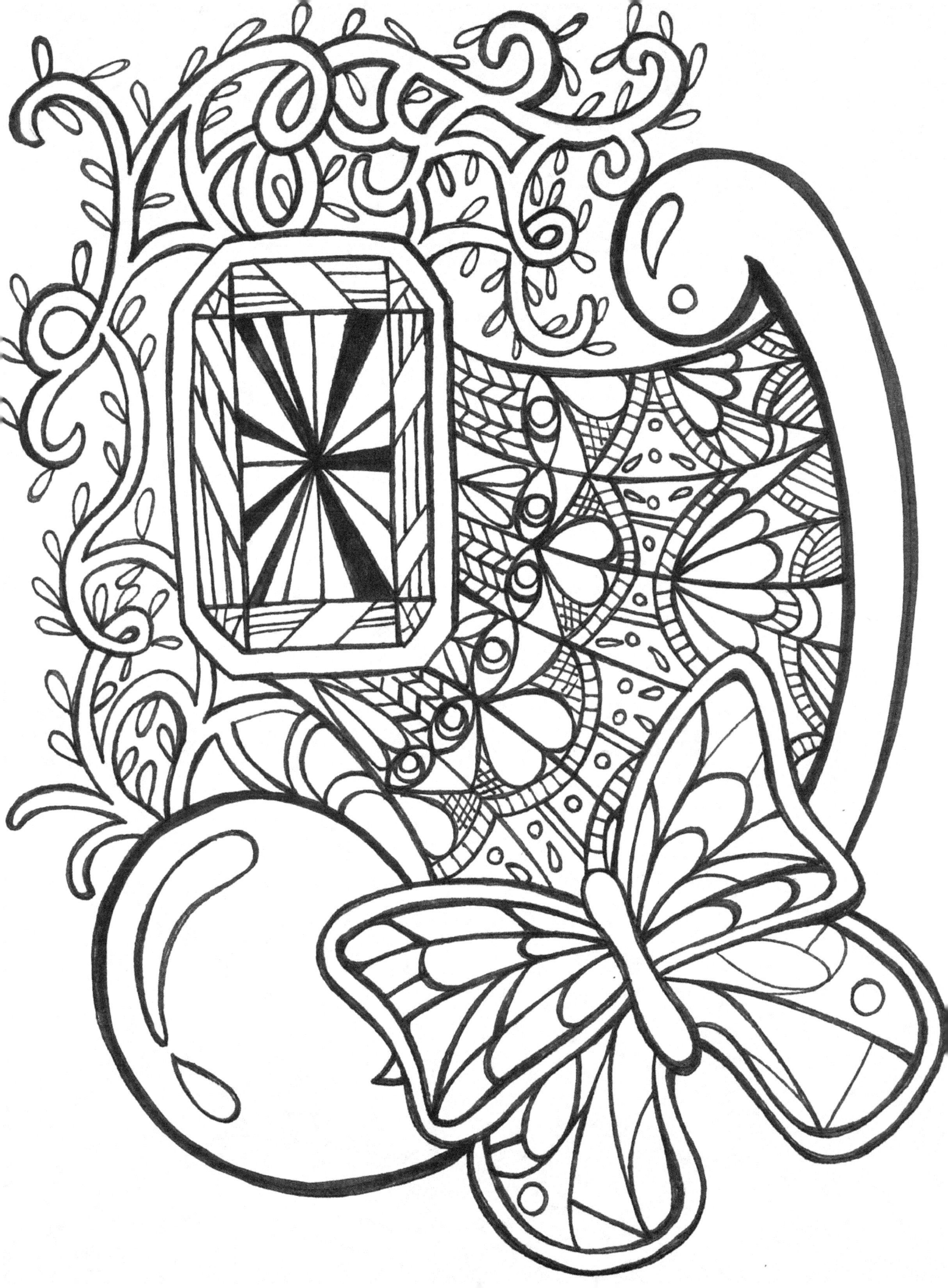

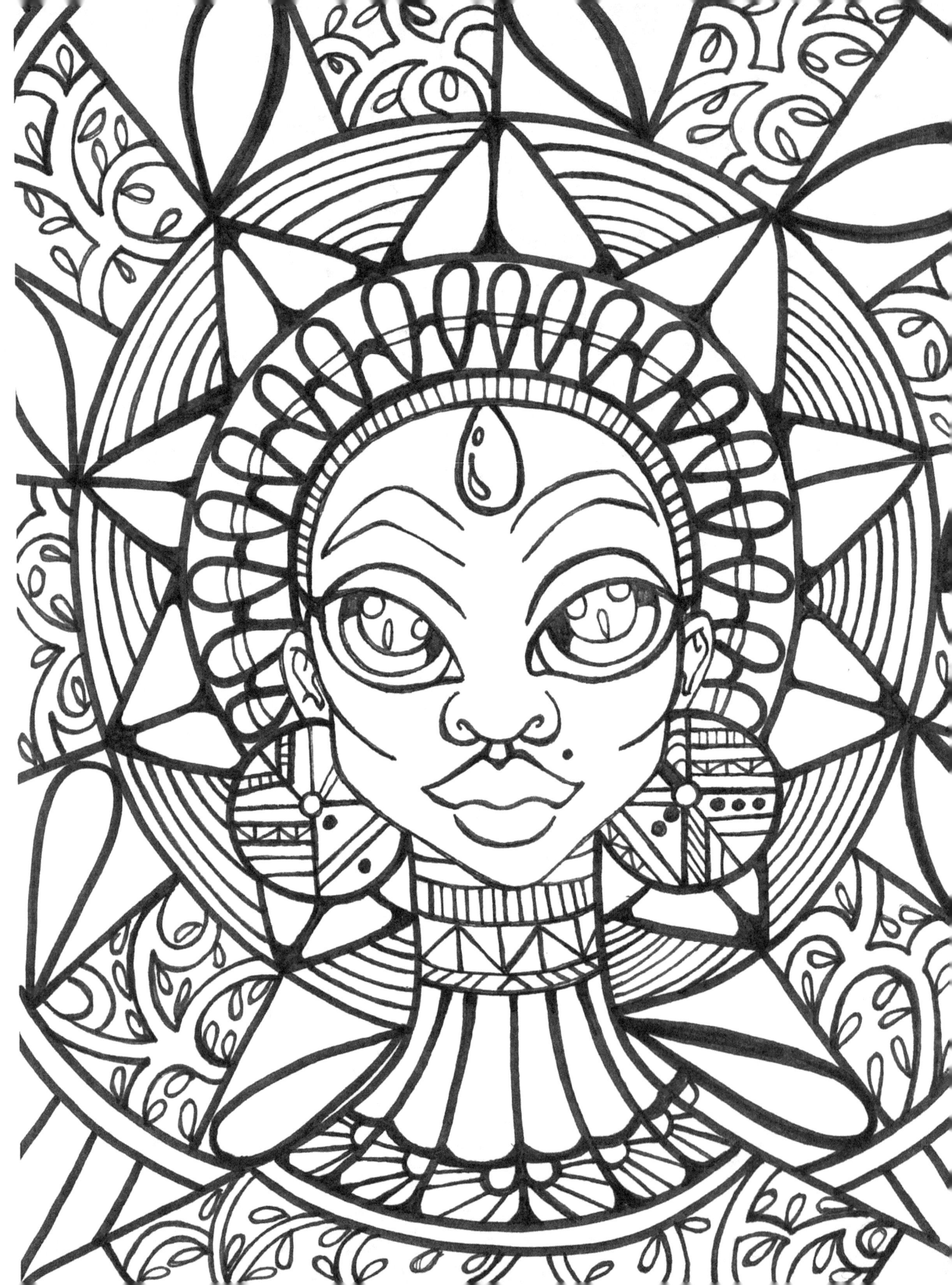

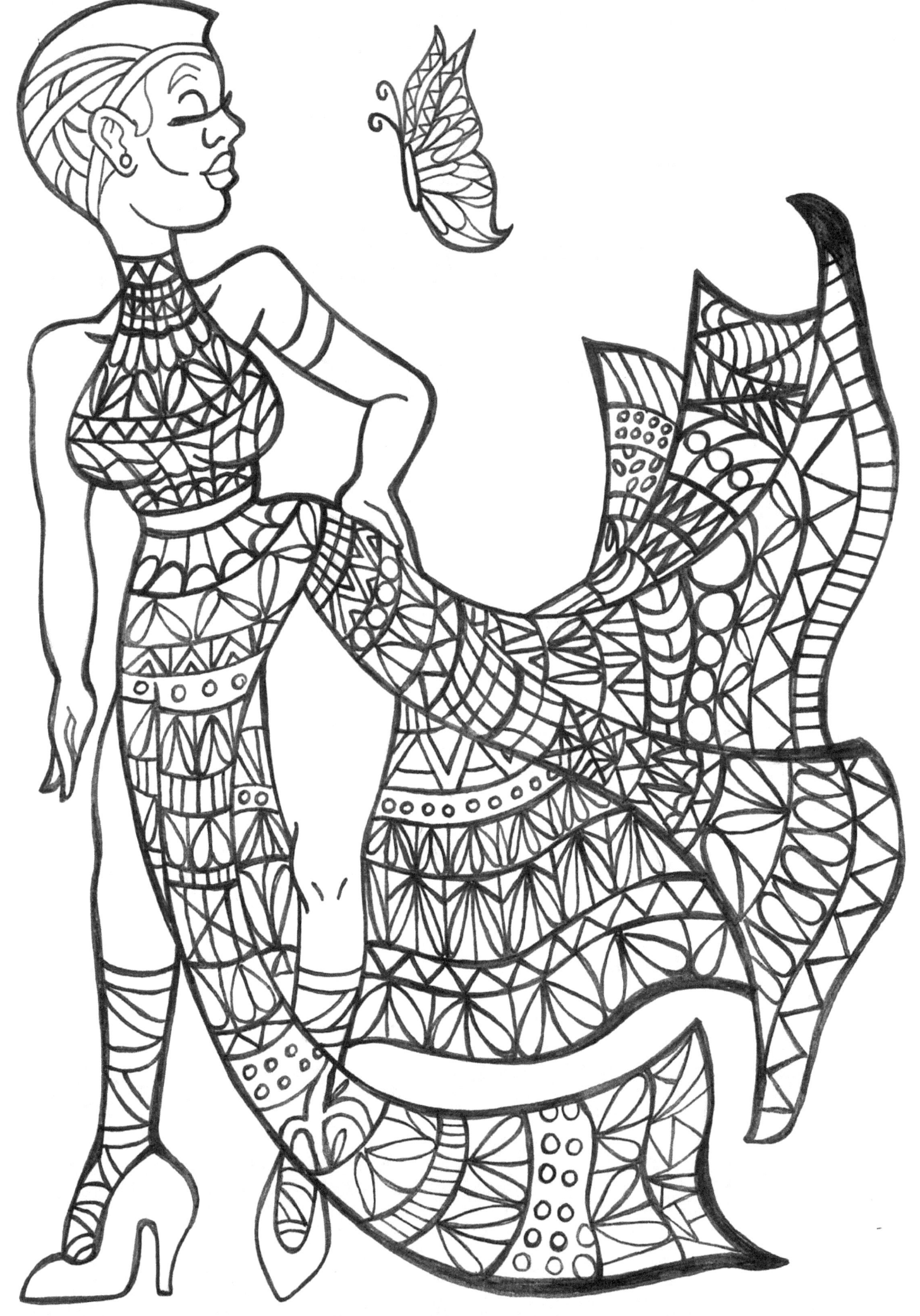

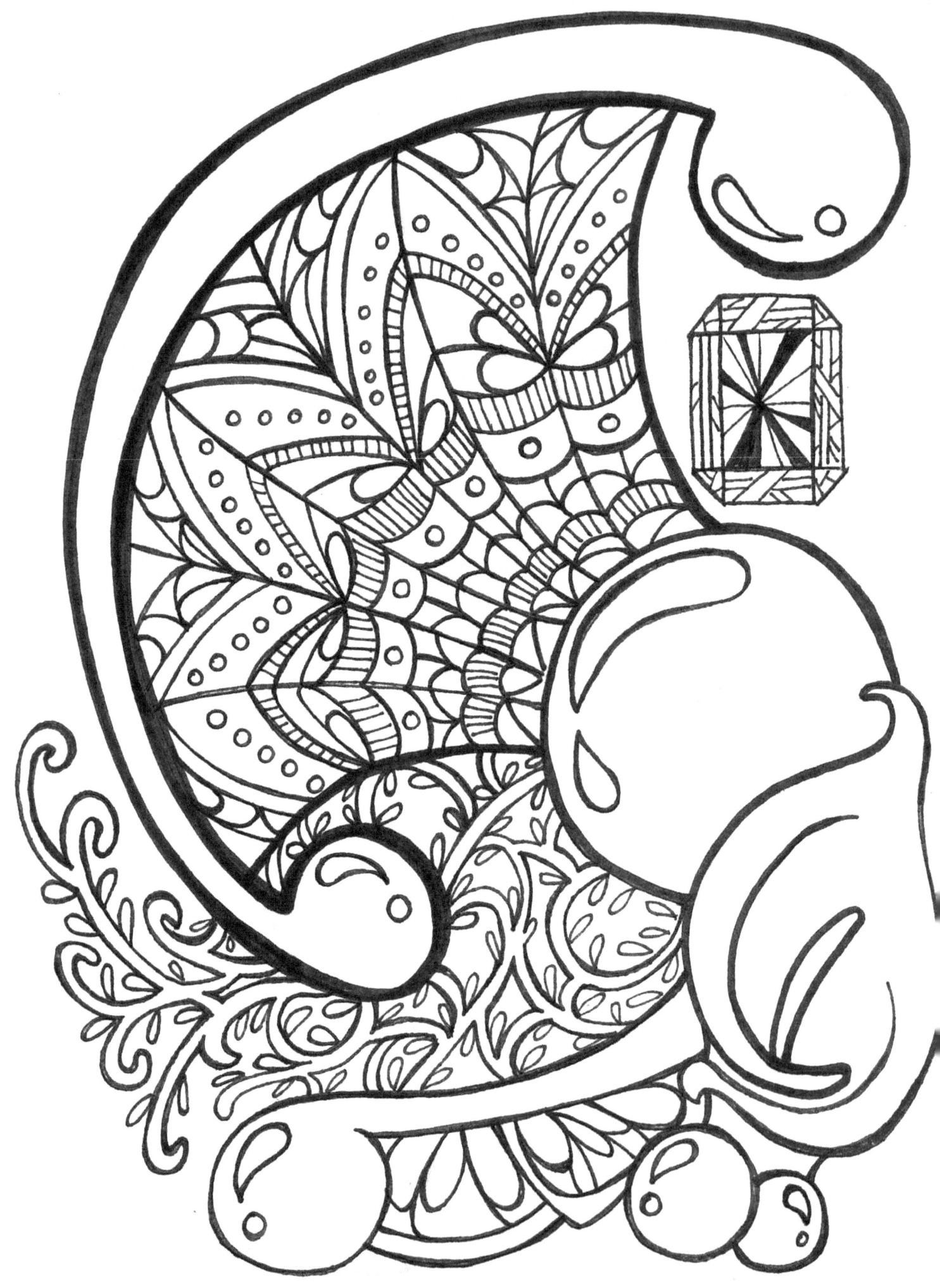

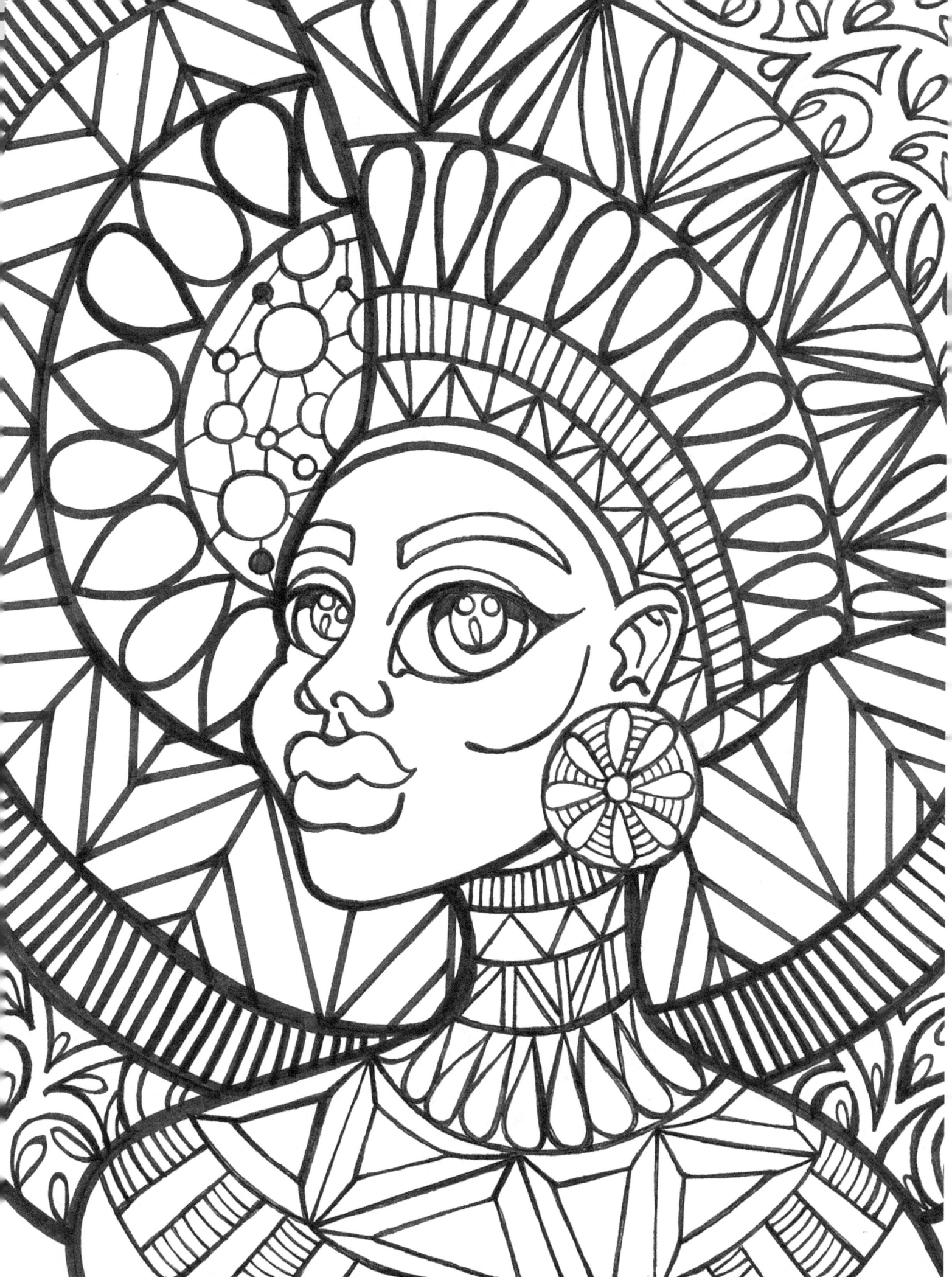

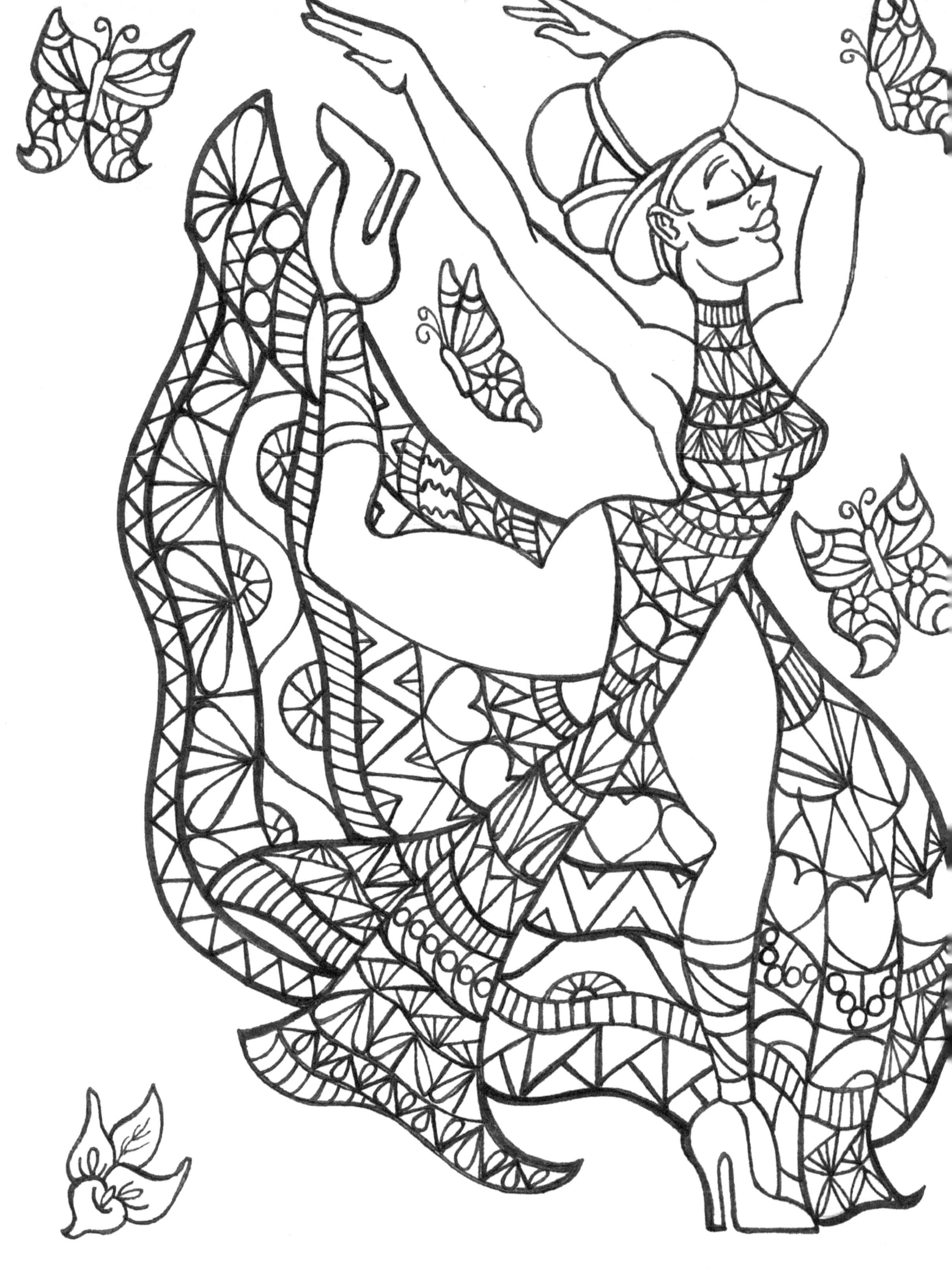

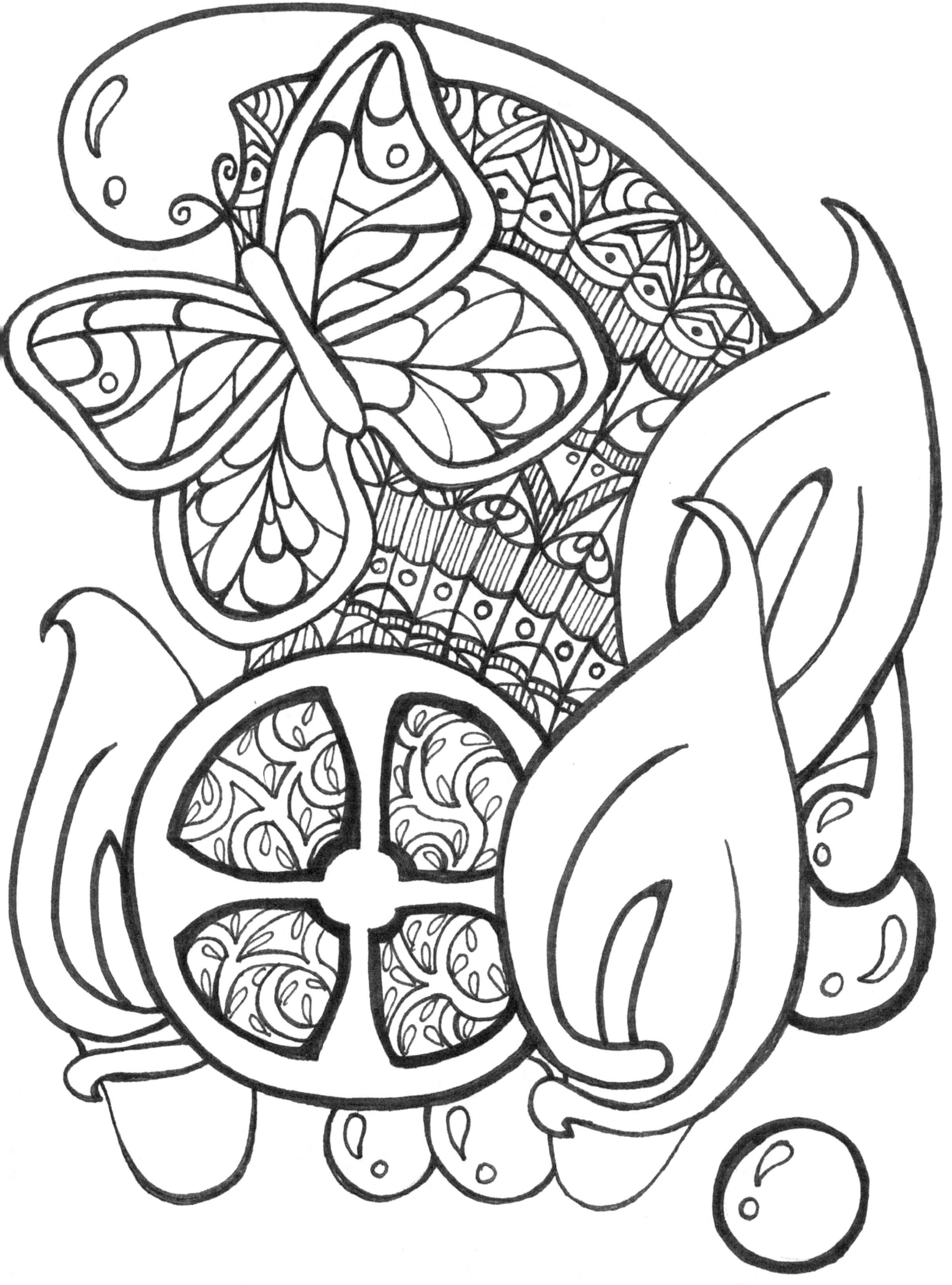

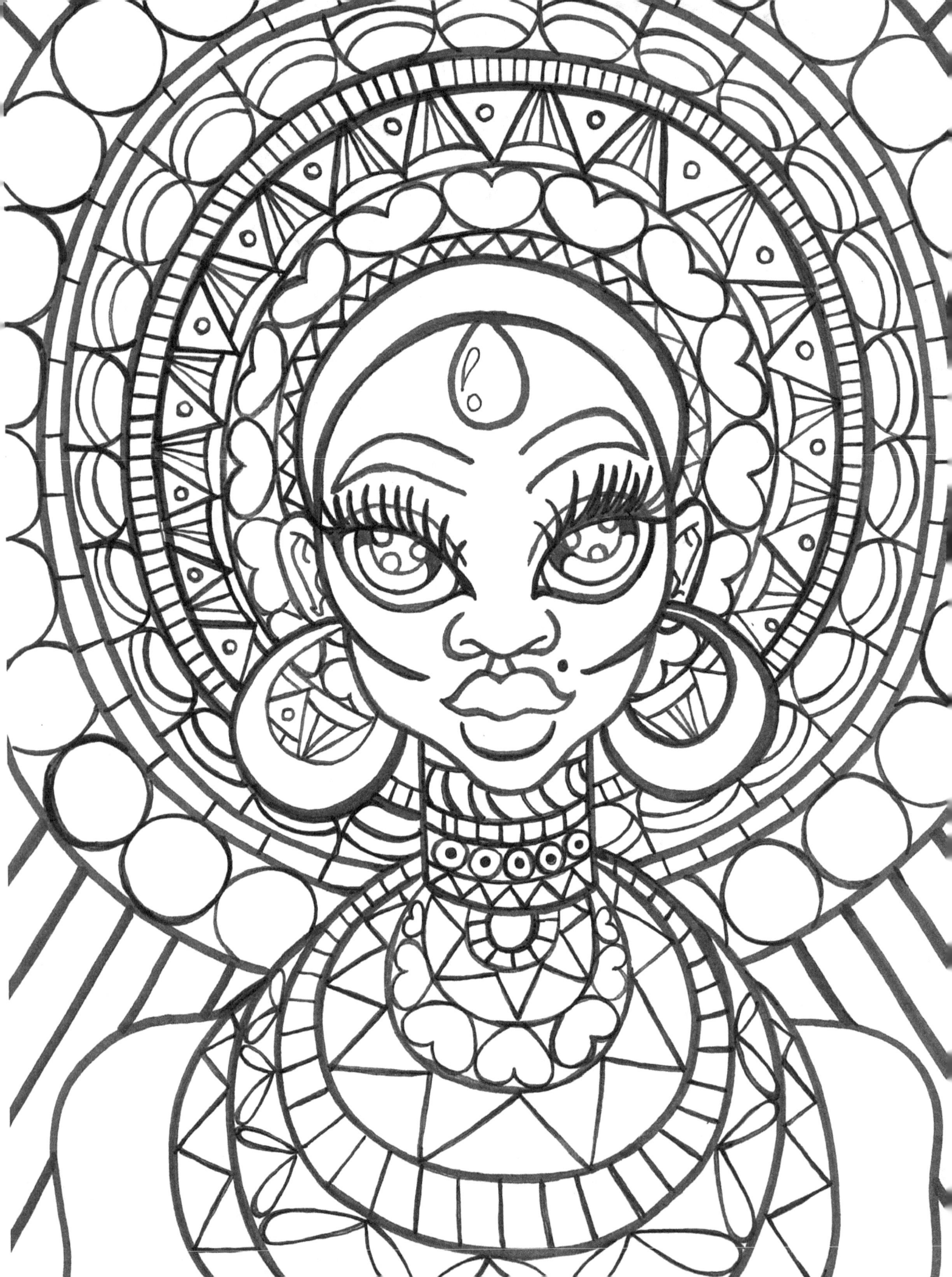

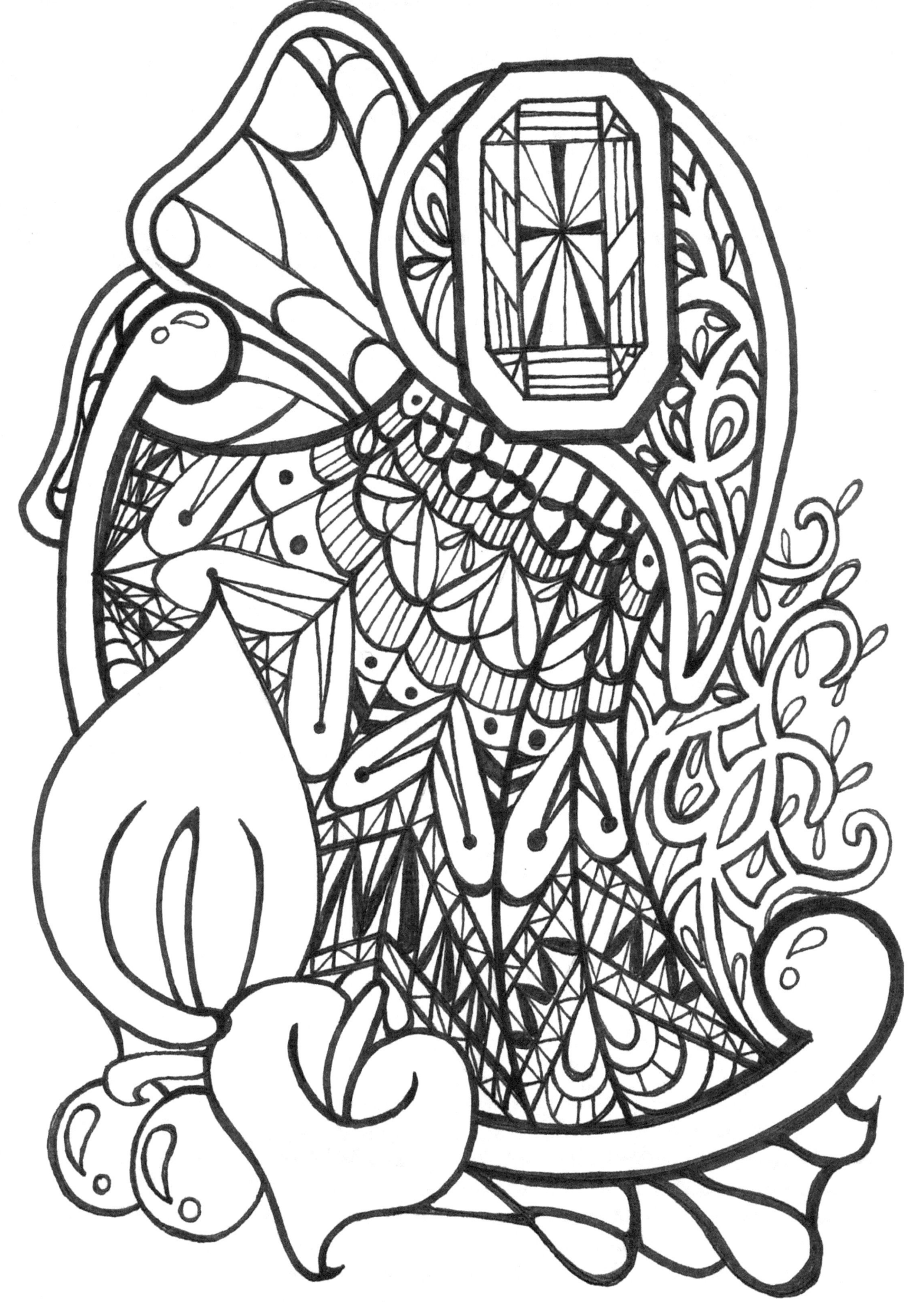

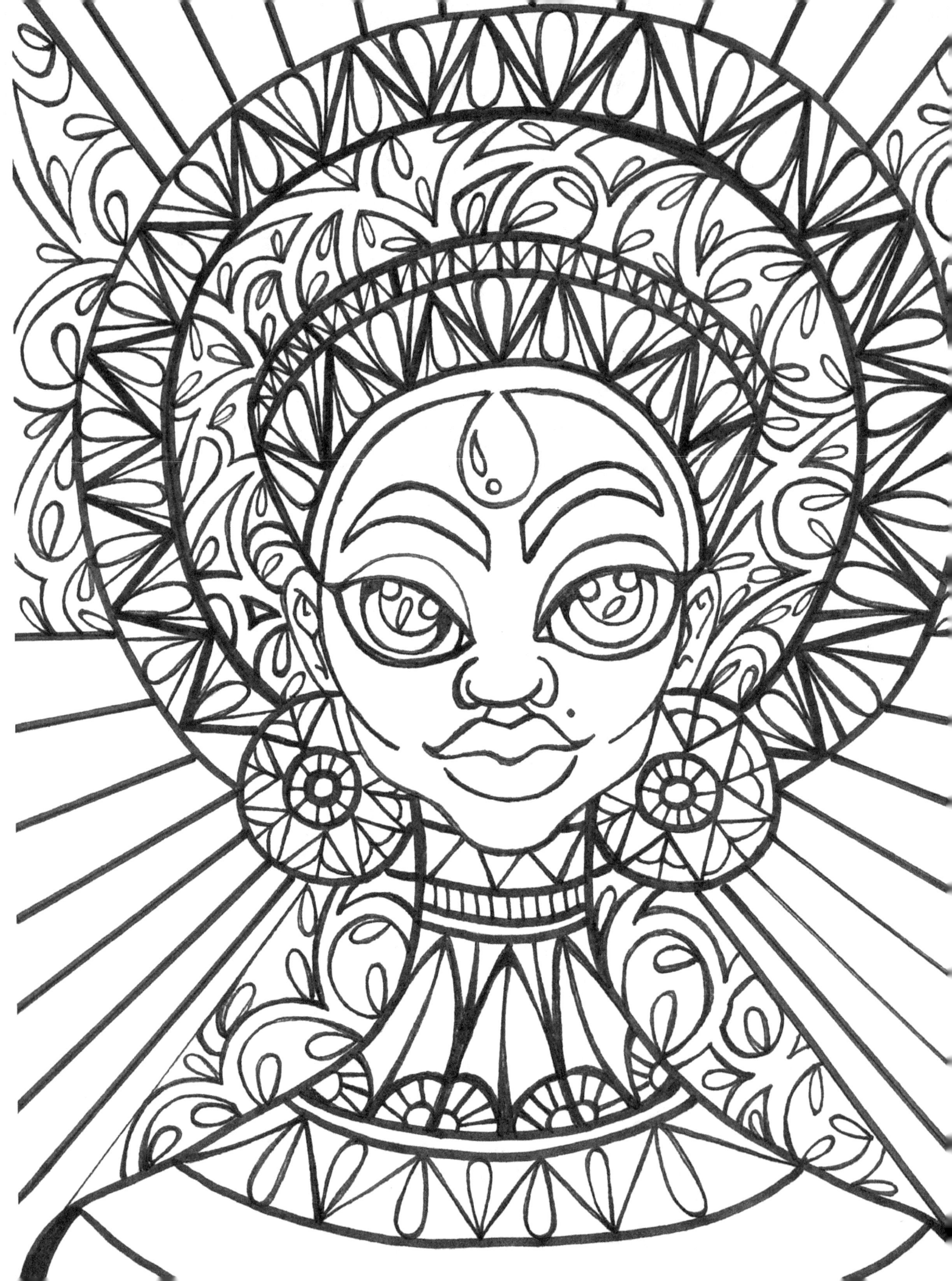

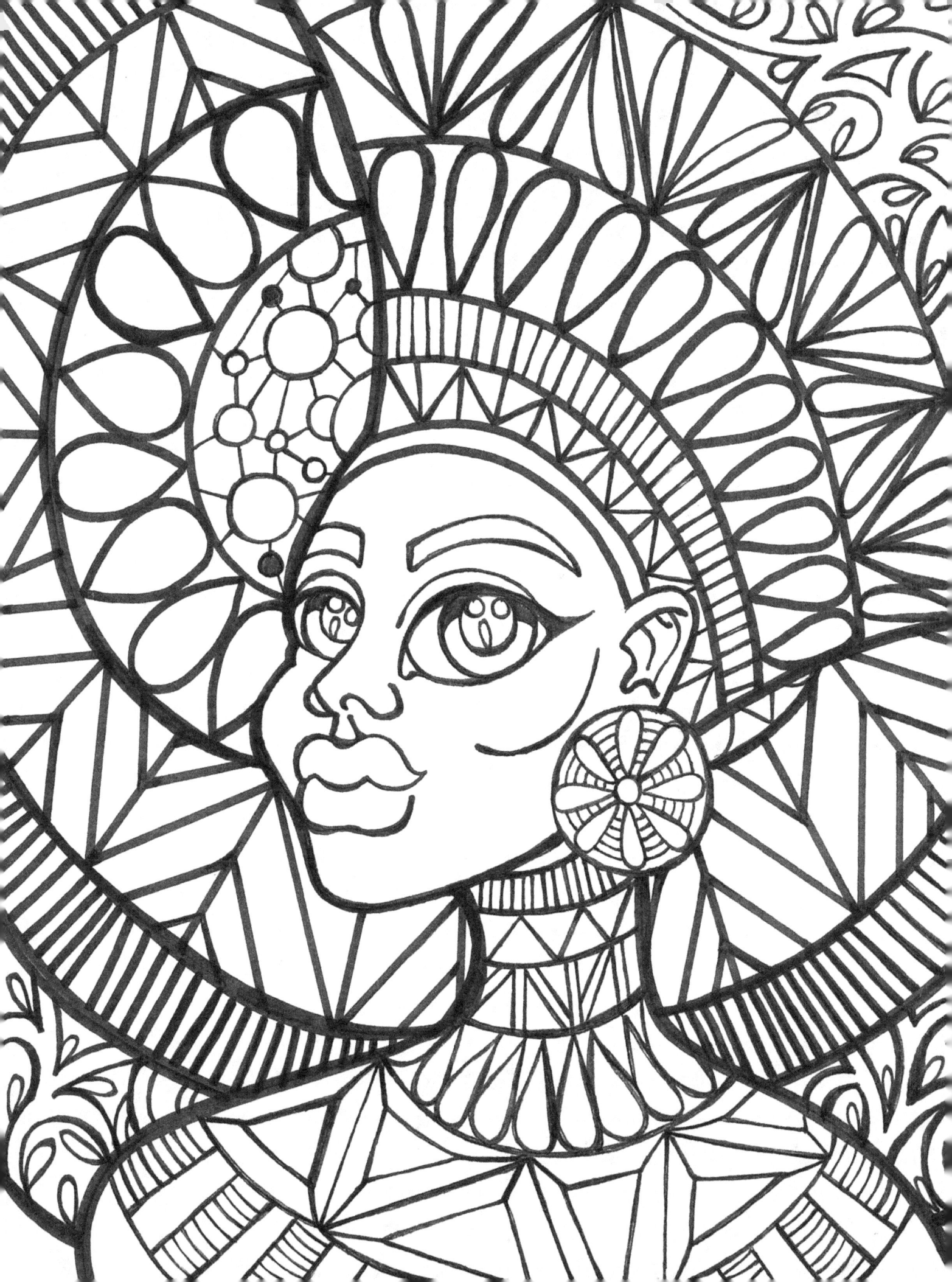

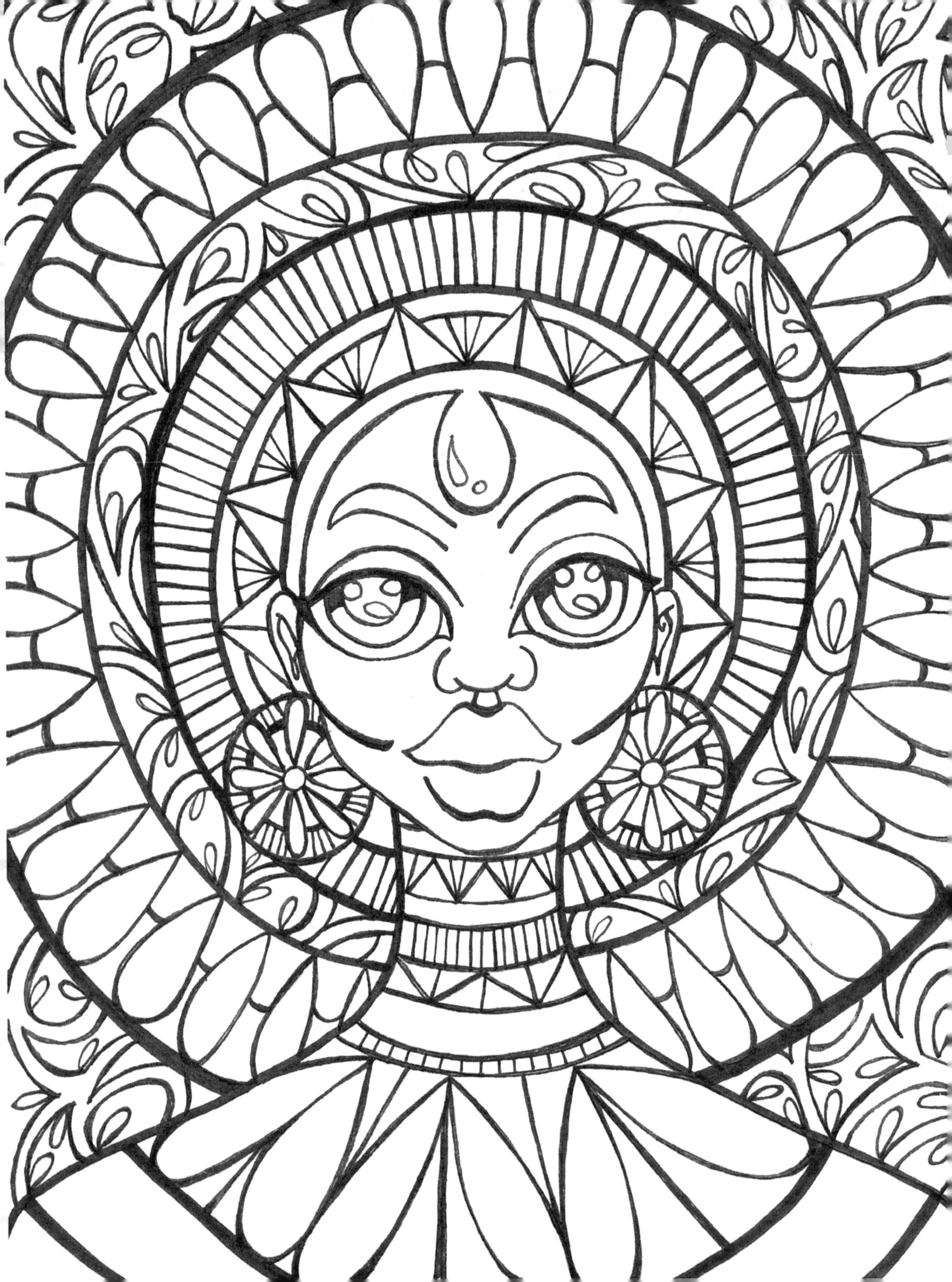

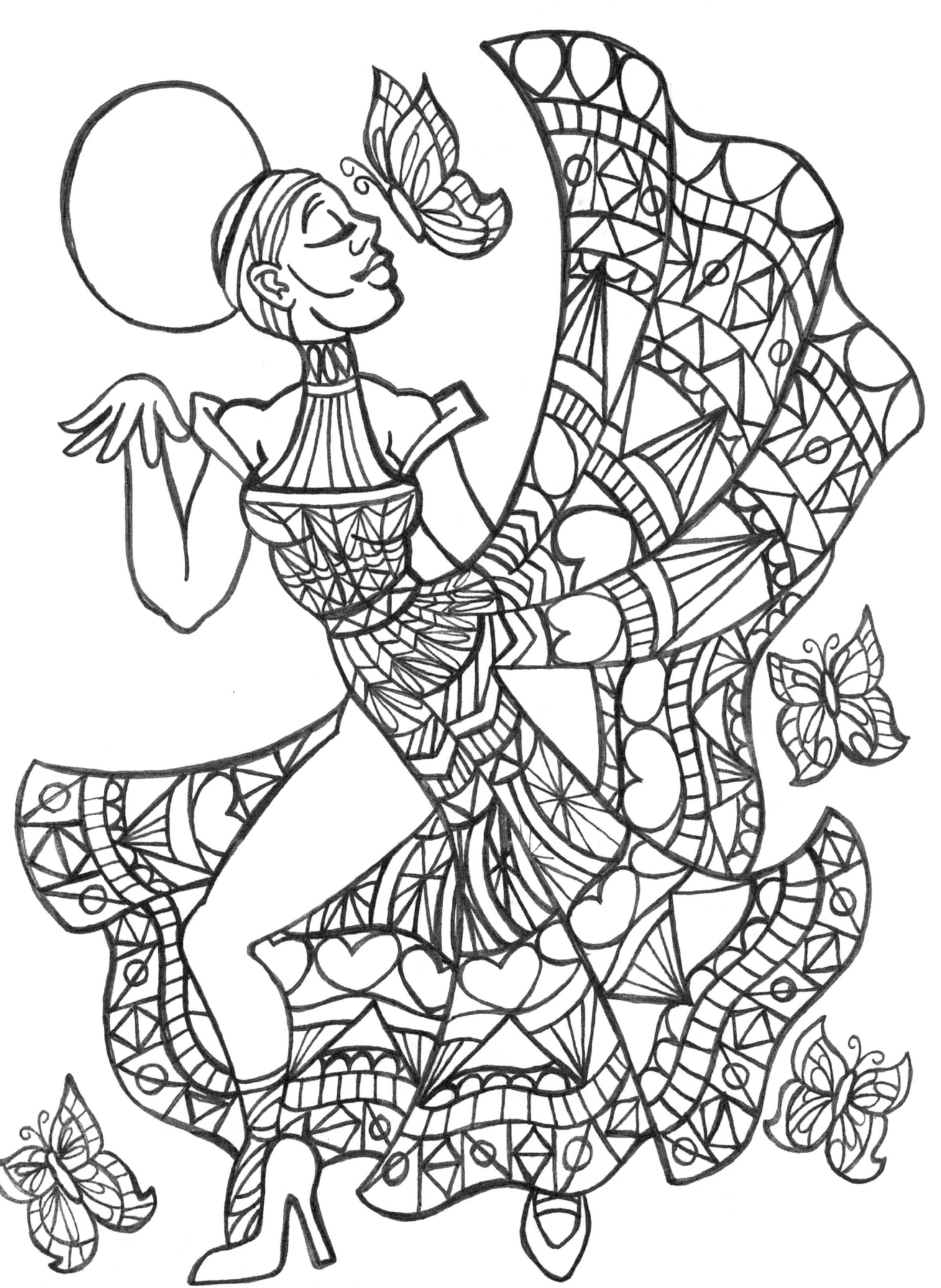

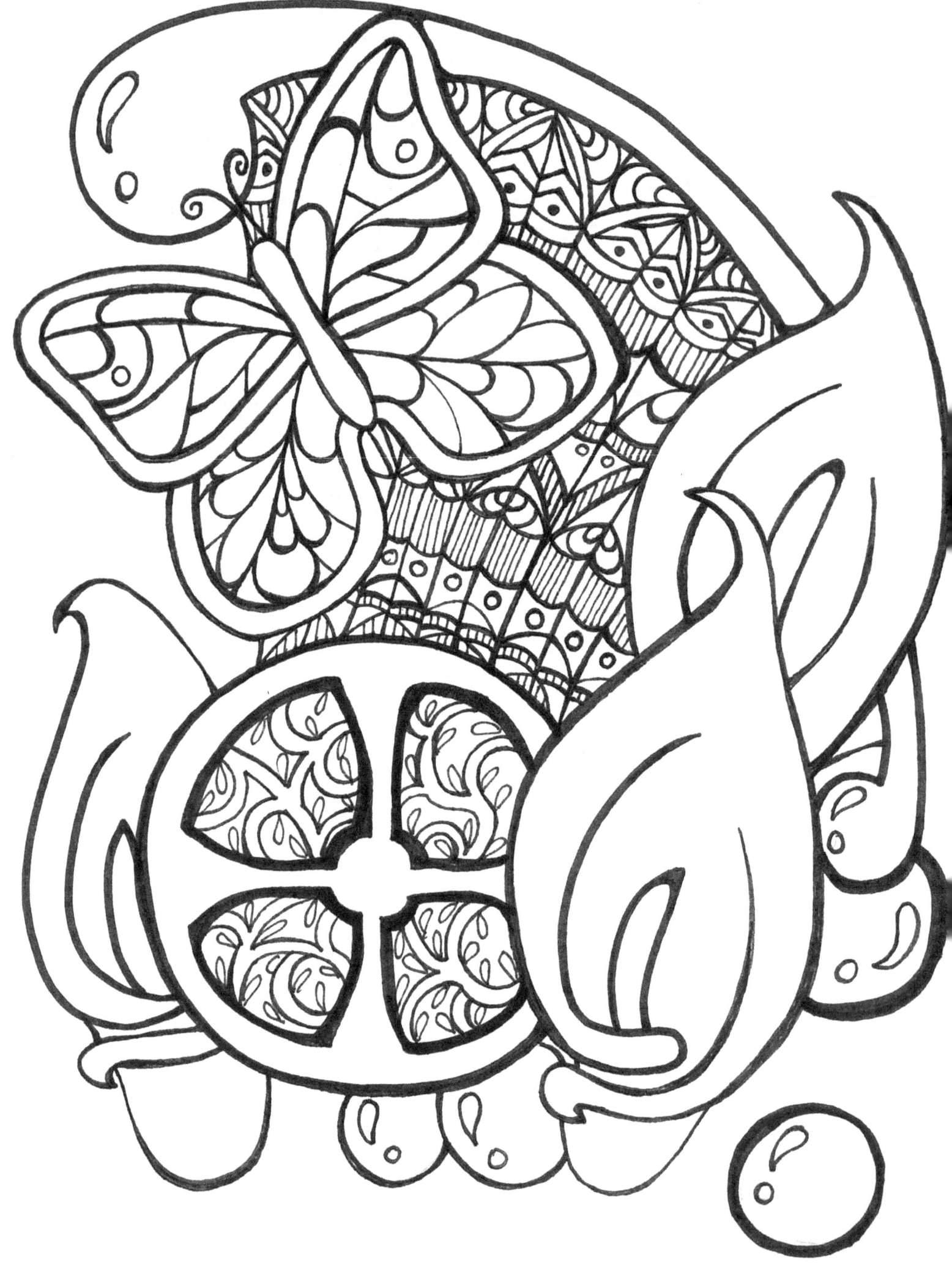

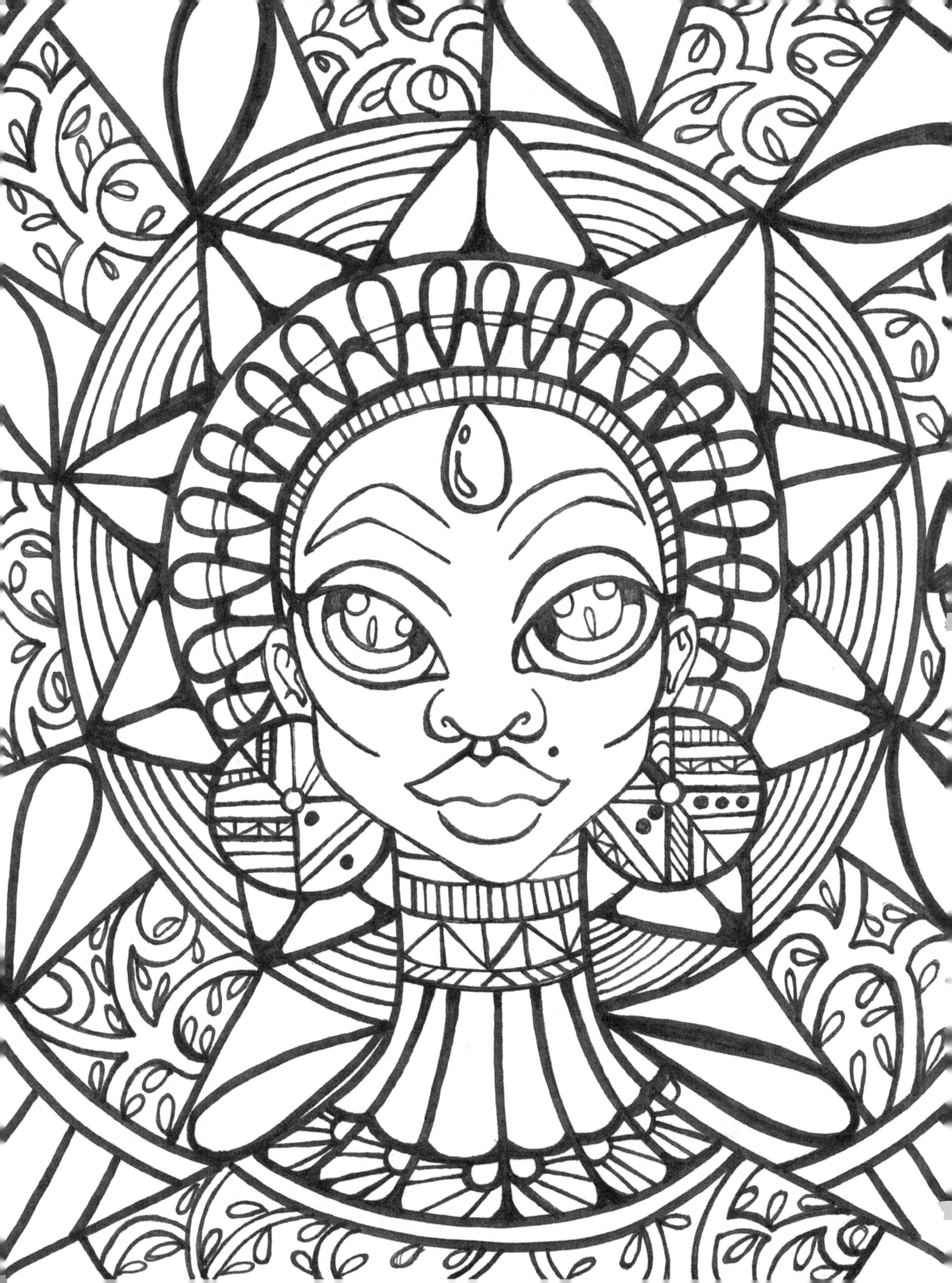

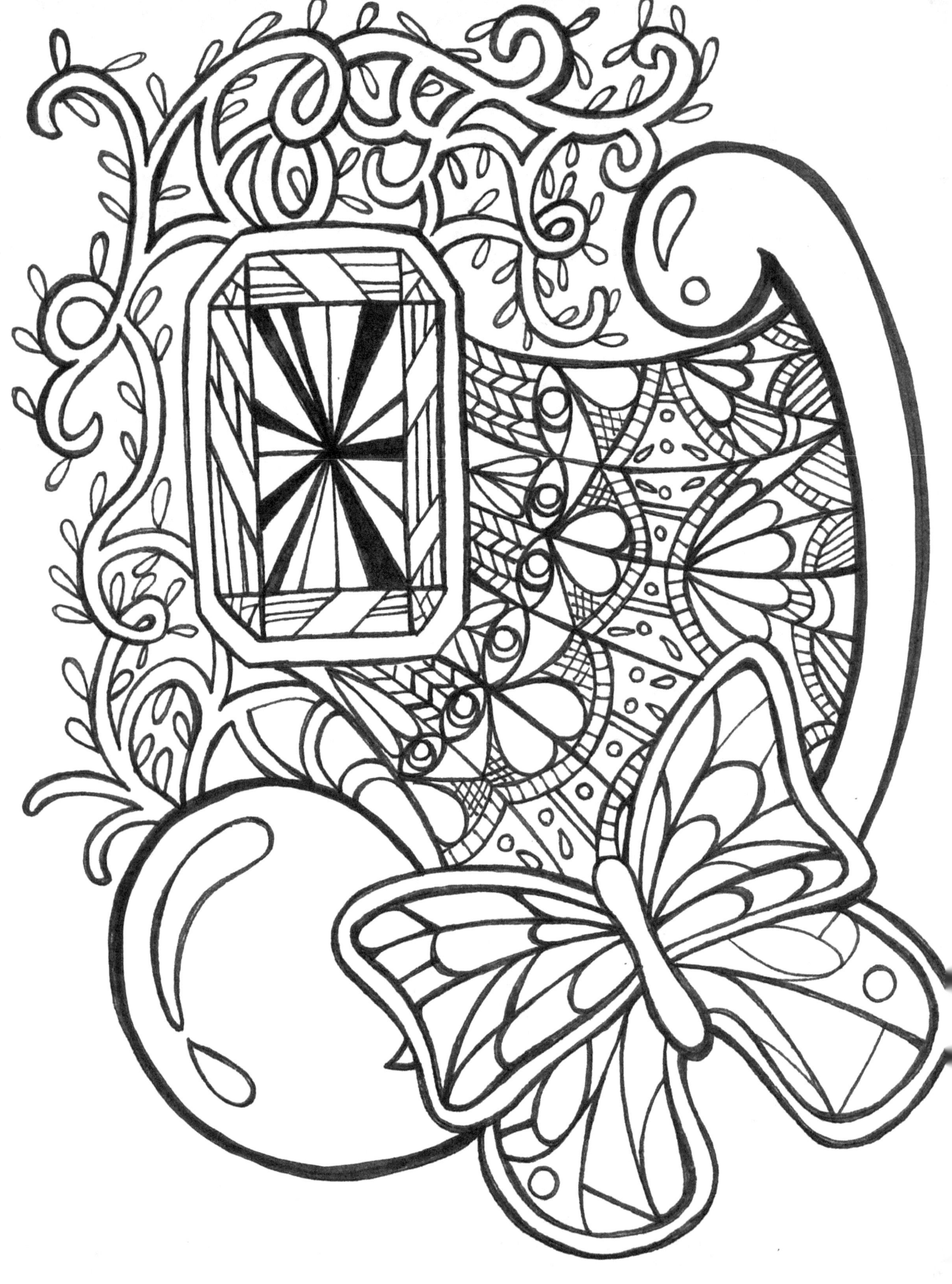

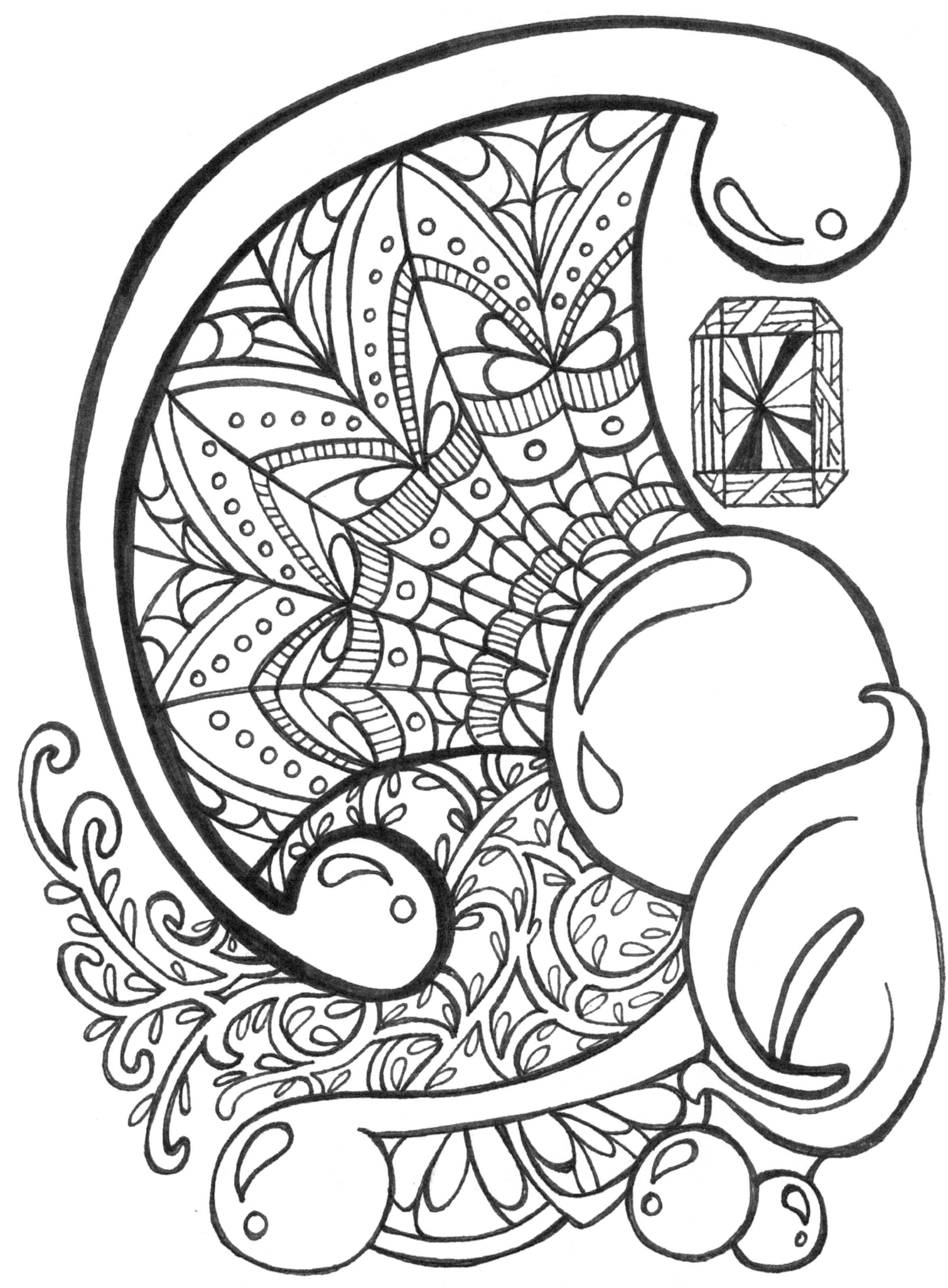

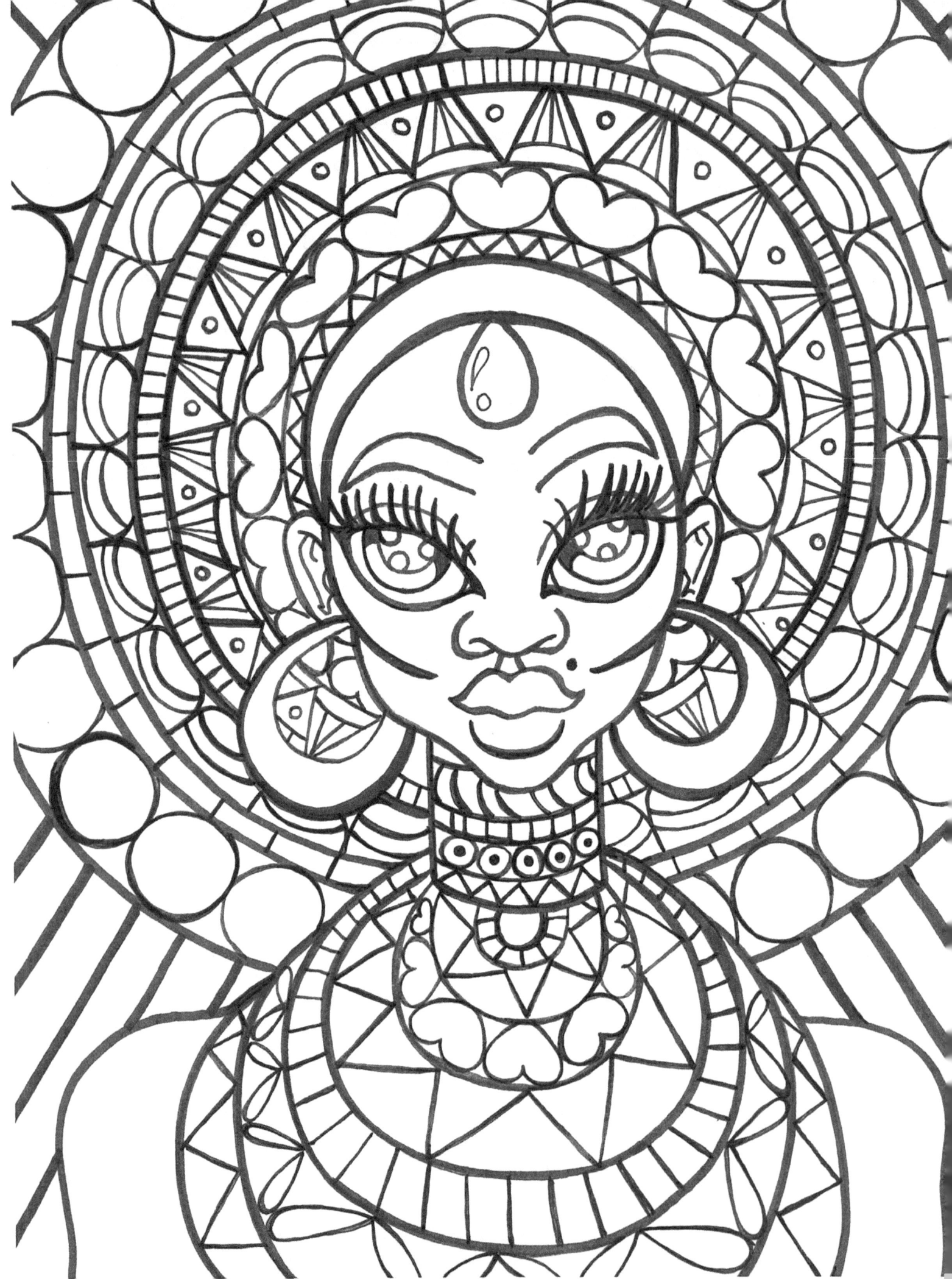

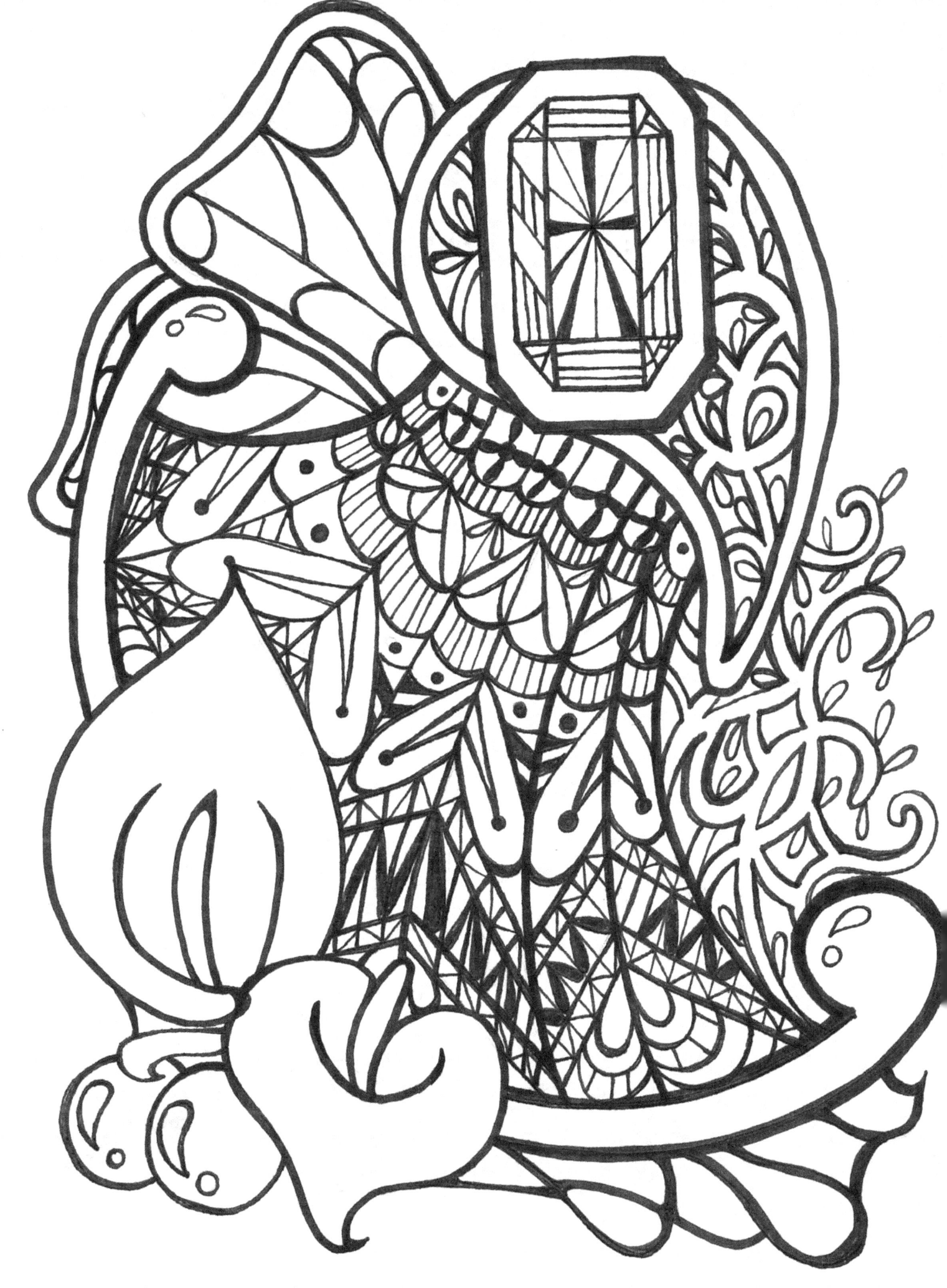

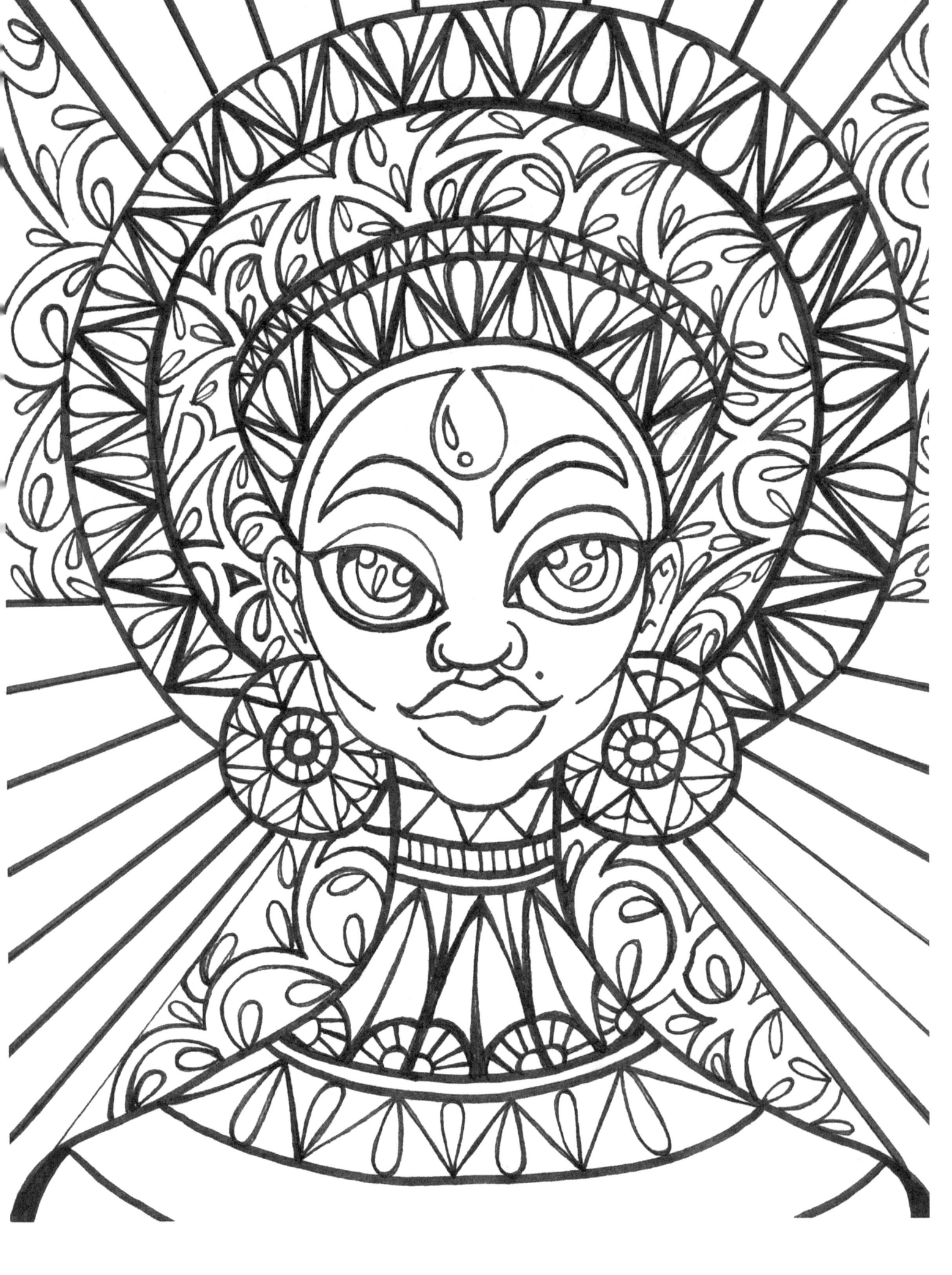

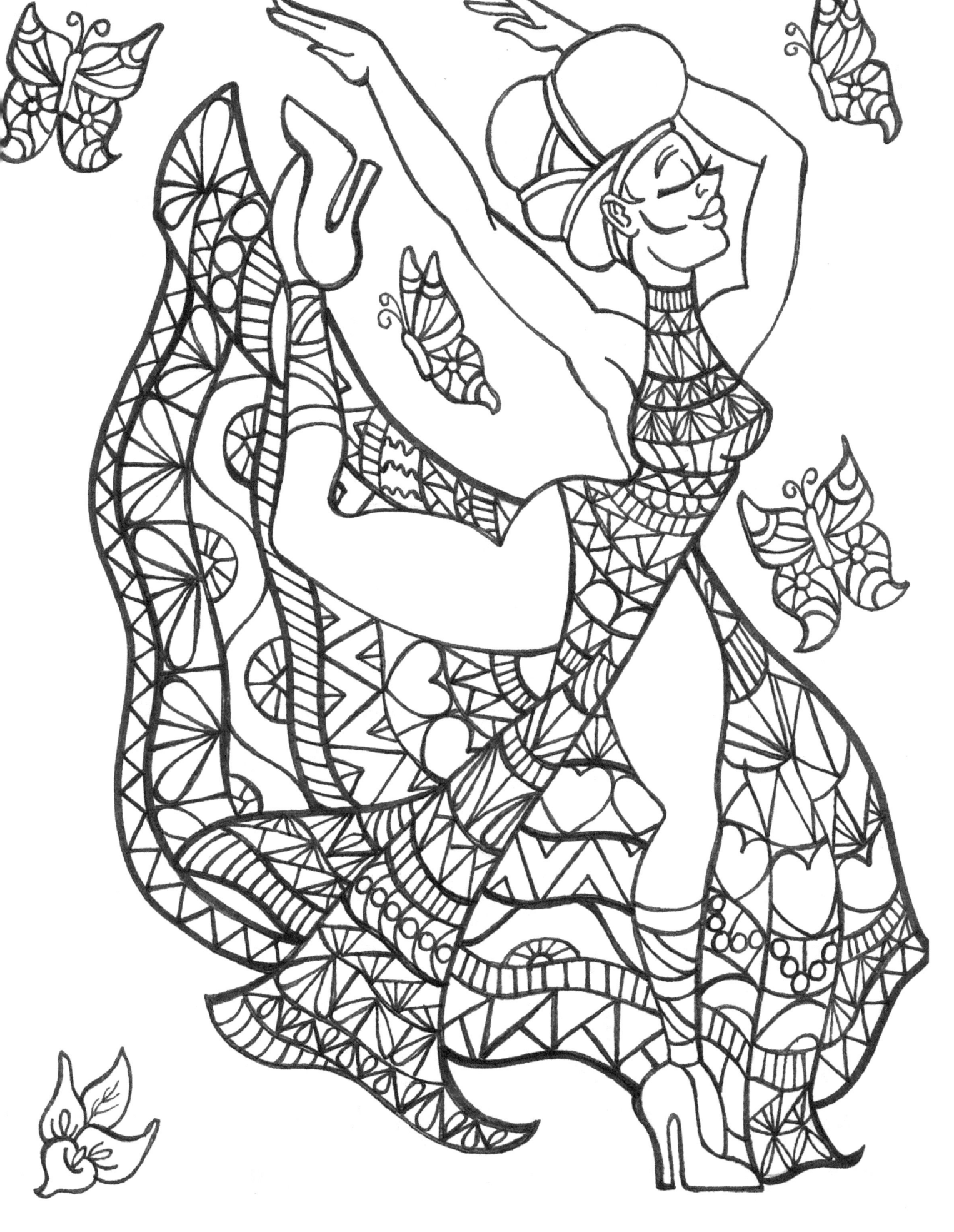

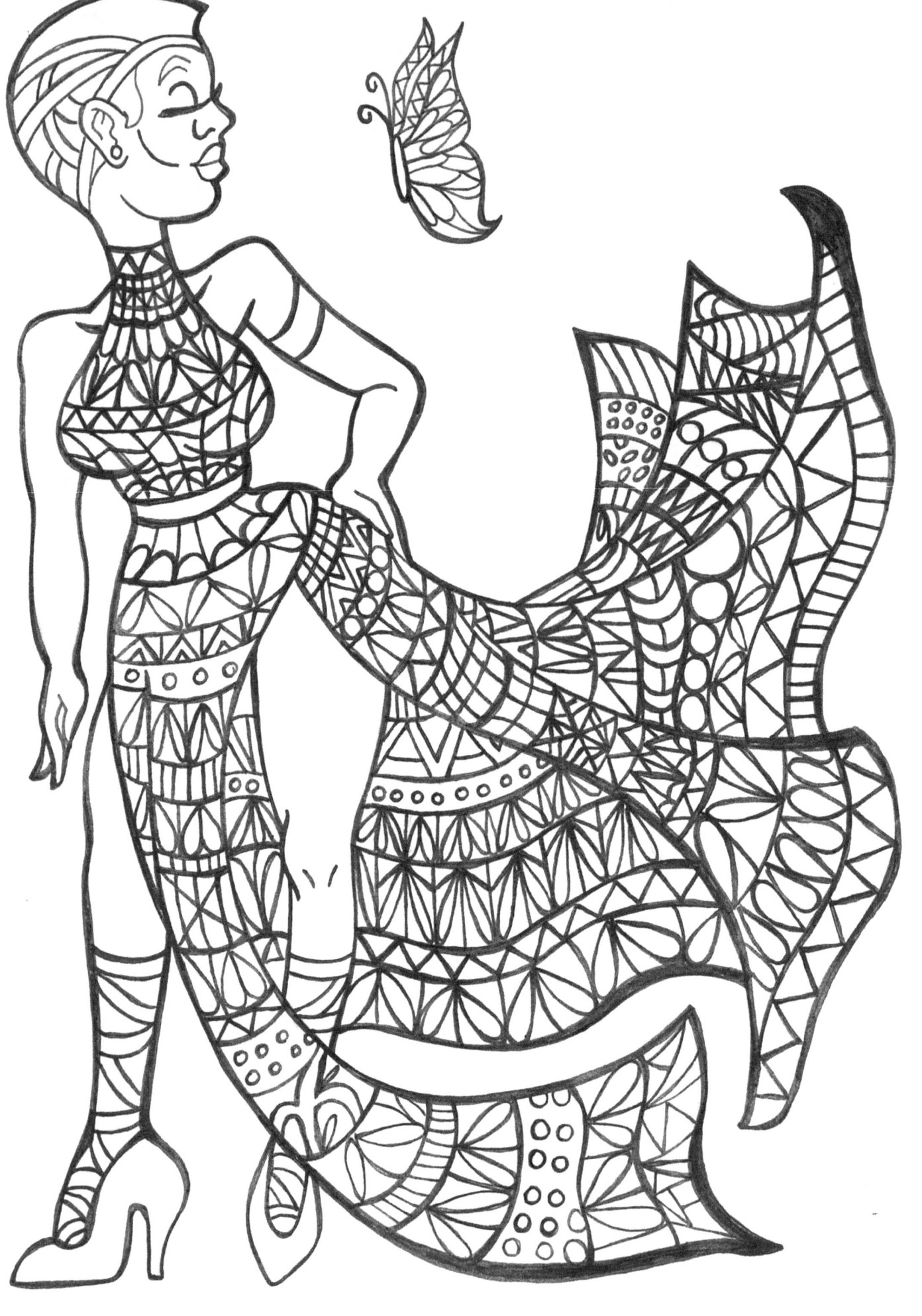

Please check out my work at

www.akeemwayne.com

Facebook: The Art of Akeem

Instagram: @artbyakeemwayne

Created by

Artist Akeem Wayne Scott

©2017

All rights reserved

www.ingramcontent.com/pod-product-compliance
Lightning Source LLC
Chambersburg PA
CBHW081135180526
45170CB00008B/3114